Free Hand Drawing
and
Designing

BY

MAX KUSHLAN

S. B. Assoc., W. S. E.

Copyright © 2013 Read Books Ltd.
This book is copyright and may not be
reproduced or copied in any way without
the express permission of the publisher in writing

British Library Cataloguing-in-Publication Data
A catalogue record for this book is available from the
British Library

Technical Drawing and Drafting

Technical drawing, also known as 'drafting' or 'draughting', is the act and discipline of composing plans that visually communicate how something functions or is to be constructed.

It is essential for communicating ideas in industry, architecture and engineering. The need for precise communication in the preparation of a functional document distinguishes technical drawing from the expressive drawing of the visual arts. Whereas artistic drawings are subjectively interpreted, with multiply determined meanings, technical drawings generally have only one intended meaning. To make the drawings easier to understand, practitioners use familiar symbols, perspectives, units of measurement, notation systems, visual styles, and page layout. Together, such conventions constitute a visual language, and help to ensure that the drawing is unambiguous and relatively easy to understand.

There are many methods of constructing a technical drawing, and most simple among them is a sketch. A sketch is a quickly executed, freehand drawing that is not intended as a finished work. In general, sketching is a quick way to record an idea for later use, and architects sketches in particular (in a very similar manner to fine artists) serve as a way to try out different ideas and establish a composition before undertaking more finished work. Architects drawings can also be used to convince clients of the merits of a design, to enable a building constructer to use them, and as a record

of completed work. In a similar manner to engineering (and all other technical drawings), there is a set of conventions (i.e particular views, measurements, scales, and cross-referencing) that are utilised.

As opposed to free-sketching, technical drawings usually utilise various manuals and instruments. The basic drafting procedure is to place a piece of paper (or other material) on a smooth surface with right-angle corners and straight sides – typically a drawing board. A sliding straightedge known as a 'T-square' is then placed on one of the sides, allowing it to be slid across the side of the table, and over the surface of the paper. Parallel lines can be drawn simply by moving the T-square and running a pencil along the edge, as well as holding devices such as set squares or triangles. Other tools can be used to draw curves and circles, and primary among these are the compasses, used for drawing simple arcs and circles. Drafting templates are also utilised in cases where the drafter has to create recurring objects in a drawing – a massive time-saving development.

This basic drafting system requires an accurate table and constant attention to the positioning of the tools. A common error is to allow the triangles to push the top of the T-square down slightly, thereby throwing off all the angles. Even tasks as simple as drawing two angled lines meeting at a point require a number of moves of the T-square and triangles, and in general drafting this can be a time consuming process. In addition to the mastery of the mechanics of drawing lines, arcs, circles (and text) onto a piece of paper – the drafting effort requires a thorough understanding of geometry, trigonometry and spatial

comprehension. In all cases, it demands precision and accuracy, and attention to detail.

Conventionally, drawings were made in ink on paper or a similar material, and any copies required had to be laboriously made by hand. The twentieth century saw a shift to drawing on tracing paper, so that mechanical copies could be run off efficiently. This was a substantial development in the drafting process – only eclipsed in the twenty-first century with 'computer-aided-drawing' systems (CAD). Although classical draftsmen and women are still in high demand, the mechanics of the drafting task have largely been automated and accelerated through the use of such systems. The development of the computer had a major impact on the methods used to design and create technical drawings, making manual drawing almost obsolete, and opening up new possibilities of form using organic shapes and complex geometry.

Today, there are two types of computer-aided design systems used for the production of technical drawings; two dimensions ('2D') and three dimensions ('3D'). 2D CAD systems such as AutoCAD or MicroStation have largely replaced the paper drawing discipline. Lines, circles, arcs and curves are all created within the software. It is down to the technical drawing skill of the user to produce the drawing – though this method does allow for the making of numerous revisions, and modifications of original designs. 3D CAD systems such as Autodesk Inventor or SolidWorks first produce the geometry of the part, and the technical drawing comes from user defined views of the part. This means there is little scope for error once the parameters have been set.

Buildings, Aircraft, ships and cars are now all modelled, assembled and checked in 3D before technical drawings are released for manufacture.

Technical drawing is a skill that is essential for so many industries and endeavours, allowing complex ideas and designs to become reality. It is hoped that the current reader enjoys this book on the subject.

TABLE OF CONTENTS

CHAPTER		PAGE
I	Straight Lines	1
II	Curved Lines	8
III	Geometrical Bodies	16
IV	Perspective Drawing	23
V	Technical Illustrations	29
VI	Technical Sketching	38

AND

ENGINEERING DRAWING

BY

JOSEPH G. BRANCH

FREE HAND DRAWING

CHAPTER I.

One of the greatest requirements of the modern engineer is to be able to make rapid neat sketches freehand, i. e. without the use of any drafting instruments, but simply by employing a well sharpened soft pencil and an eraser. There are many cases in the daily practice of every engineer from the lowest to the highest ranks, when they are called upon to make a free-hand sketch of a job, and in some cases this rough sketch remains later the only available record of the condition of the job before any changes took place. It is therefore important to have such sketches done as neatly and accurately as possible so that they would convey the correct idea to the draftsman or to the man who is to carry out the particular work represented by such sketches.

There are two principal kinds of sketches employed in describing engineering work: the actual picture of the job, as it appears to the eye; and the orthographic projection of the object in the three principal planes, but drawn roughly without the aid of instruments and not to correct scale. We will endeavor in the following chapters to cover the principles of both types of sketching, beginning with the simplest objects first and then leading up to the free-hand drawing of more or less complicated parts of machinery. The text will be amply illustrated by suitable figures which are the actual reproduction of a complete course in free-hand drawing given in one of the leading technical schools in this country, and the readers are advised to follow up the exercises in the order suggested

FREE HAND DRAWING
PLATE 1.

Fig. 1 Horizontal Line

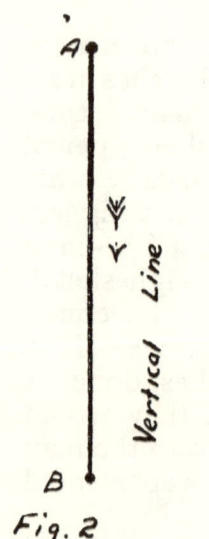

Fig. 2

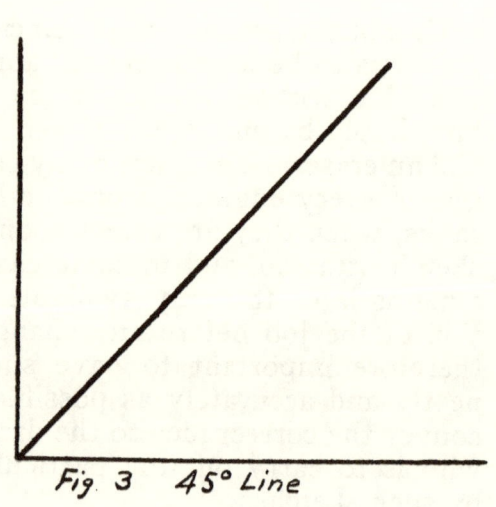

Fig. 3 45° Line

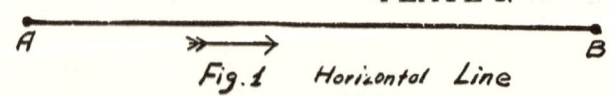

Fig. 4 – Equal Division of Line

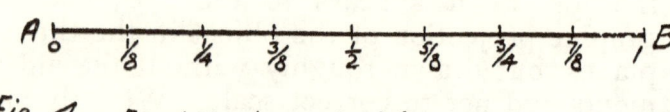

Fig 5 – Proportional Division of Line

FREE HAND DRAWING

in this course, so as to get the full benefit of the work. Each figure must be thoroughly mastered before the next one is attempted as they gradually lead from one to the other.

The first thing to learn about free-hand drawing is the correct method of looking at things. The eye must be trained to observe the size, shape and position of an object and its relation to the other objects around it. We must also be able to estimate distances and angles, not necessarily their correct values, but as they appear to our eye, which is usually out of proportion with the actual dimensions of the object. Before we learn to use the pencil we must therefore first learn to use our eyes and get the general habit of observation. It is a good plan to exercise in estimating sizes and distances of various simple objects such as tables, windows, books, wheels, etc. and then check these estimates with the correct dimensions as found by the foot-rule. It is surprising how such simple exercises help to train the eye until the student can tell the size and distance of an object within a small fraction of the actual value.

Then the hand must be trained to a steady motion of the pencil by supporting it slightly with the small finger and moving it steadily in the direction desired. The student should avoid from the very start, the practice of short, jerky movements of the pencil, indicating that the hand is undecided to proceed with the line required. This usually gives a ragged line and leads to a great waste of time in trying to keep the proper alignment. The best method is to keep up a slow but steady motion, using the eye to guide the hand in the proper direction and then correcting with the rubber. The first line should be drawn faintly, then it should be corrected by touching up the various points that appear to be out of the proper direction, and then the line is to be strengthened by applying a

FREE HAND DRAWING
PLATE 2.

Fig 6 – Rectangle

Fig 7 – Square

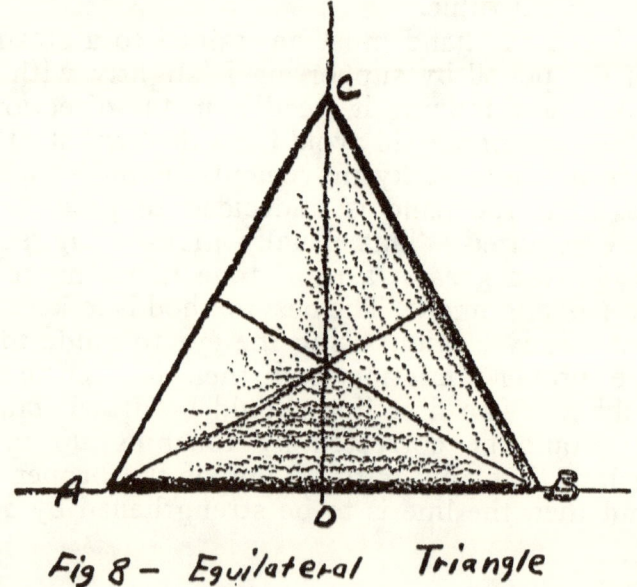

Fig 8 – Equilateral Triangle

FREE HAND DRAWING

slight pressure on the pencil, so that the result is a smooth even line of uniform thickness. No instruments should be used except once in a great while for checking the work already drawn free-hand, and then the corrections should never be made by the aid of these instrument, but the work should be gone over free-hand until it checks very closely with the instruments.

Referring to Plate I, Fig. 1 is the first and the most important element of freehand drawing, namely the horizontal straight line.

This line should always be drawn from left to right, as indicated by the arrow, and the students must keep up this exercise until they are convinced that they can draw it perfectly without spending much time. It is advisable to check each line with a straight edge, after it is completed, and then to try to improve on it when drawing the next one.

Fig. 2 is the vertical line drawn downward in the direction of the arrow. In this exercise the hand should be held in the same position as when using a knife in cutting a sheet of paper in the same direction. It is a good idea to locate a few points or short dashes along the line before the line itself is drawn.

In Fig. 3 a straight line is drawn in a direction of 45 degrees from the horizontal. In order to accomplish this the eye must be trained to estimate the angles between the line and the horizontal and vertical directions and to keep these angles as nearly equal as practicable.

The exercise shown in Fig. 4 and 5 is to train the eye and hand to estimating divisions of a line. If the number of divisions are even, it is a good plan to begin by dividing the line into two equal portions, and when that is accomplished, divide each half in the same manner. In dividing a line into 5 equal parts, lay off a mark at a point between the second and

third portion, then divide the first part in halves, and the second part into three equal parts. If a line is to be divided in a certain proportion as indicated in Fig. 5, divide the line into as many equal portions as are contained in the sum of the two numbers of the proportion required. Thus if a line is to be divided in the ration of 5 to 7, lay off 12 equal parts, and then take 5 parts for the first portion, and 7 parts for the second portion.

This set of exercises must be thoroughly finished in every detail so that the eye and the hand work in harmony and the lines and their divisions are correct within 5 per cent at least, before any attempt is made to take up the work of the next plate.

The next step is to draw a correct rectangle, as shown in Fig. 6, Plate II, where the proper shading is added to give a better effect. The horizontal lines are drawn first as nearly parallel as could be done. Then one vertical line is drawn at right angles to the first two, and equal spaces are laid off on each horizontal line from their points of intersection with the vertical line; these points are connected by another vertical line, guiding it so that it is at right angles to the two horizontal sides and is parallel to the other vertical side.

In drawing a square, as shown in Fig. 7, care should be taken to lay off the horizontal spaces equal to the vertical distance between the lines, since to the eye vertical lines always appear longer than horizontal lines of the same size, and the sides should be carefully checked by means of instruments until the student acquires the proper training in allowing for this optical illusion.

The equlateral (equal-sided) triangle is drawn by first laying out a horizontal axis A B (see Fig 8, Plate II) and dividing line A B into halves at point D, and from D draw a vertical line at right angles to

A B. Try to locate on this vertical line a point C such that when connecting points A and B with point C. we will have lines AC and BC equal to AB. This will be rather difficult at first, but after a few trials the student will be able to find the correct point without any trouble. The lengths of the sides of the triangle can be checked roughly by making use of the pencil in laying off with the fingernail the size of AB from the end of the pencil then comparing this with the other two sides, carrying the pencil with the marking finger around to the different lines to be measured. This furnishes a rough method for checking lengths and is frequently used by engineers in making sketches on the job. When the triangle is drawn correctly then the other two equal sides AC and BC (see Fig. 8) should be divided in halves, and each middle point should be connected with its opposite vertex. The three lines drawn in such a manner from the vertices should meet in one common point as shown in the figure, making the whole arrangement perfectly symmetrical.

CHAPTER II.

Curved Lines.

The ability to draw curved lines correctly seems at first to be a good deal more difficult than the straight-line work on rectilinear figures. This opinion is, however, very far from the truth; in fact, after a few trials the student will find that it is just the reverse: it is a good deal easier to draw curved lines, since our hand is more nearly adapted for a sweeping motion along a curved path, and in drawing a straight line we are constantly deviating from a curve by a strong exertion of our will. A good deal of the success in beginning the practice with curved lines depends upon the confidence of the student in his ability to get good results; this will always produce a smoother curve due to the free and easy sweep of the determined hand, and will prevent a good deal of waste of time and energy at the very start.

There are many ways of drawing a circle correctly without the aid of a compass, some of them being rather crude and primitive; but all of these methods are helpful in certain cases, and we will mention them all, leaving it to the student's judgment to decide which would be the best to use on different occasions.

Everyone is familiar with the method of drawing circles by the help of some round object on hand, such as a coin of suitable size, a plate, or any round disk having a smooth edge. The disk is held firmly down on the paper with the left hand, the tips of the fingers being supported at a point near the center, and the pencil is held vertically in the right hand, which traces the circle, beginning from the top in a clockwise direction, care being taken not to incline

the pencil so as to distort the curve and not to move the disk from its initial position. When the right hand reaches the part of the circle to the extreme

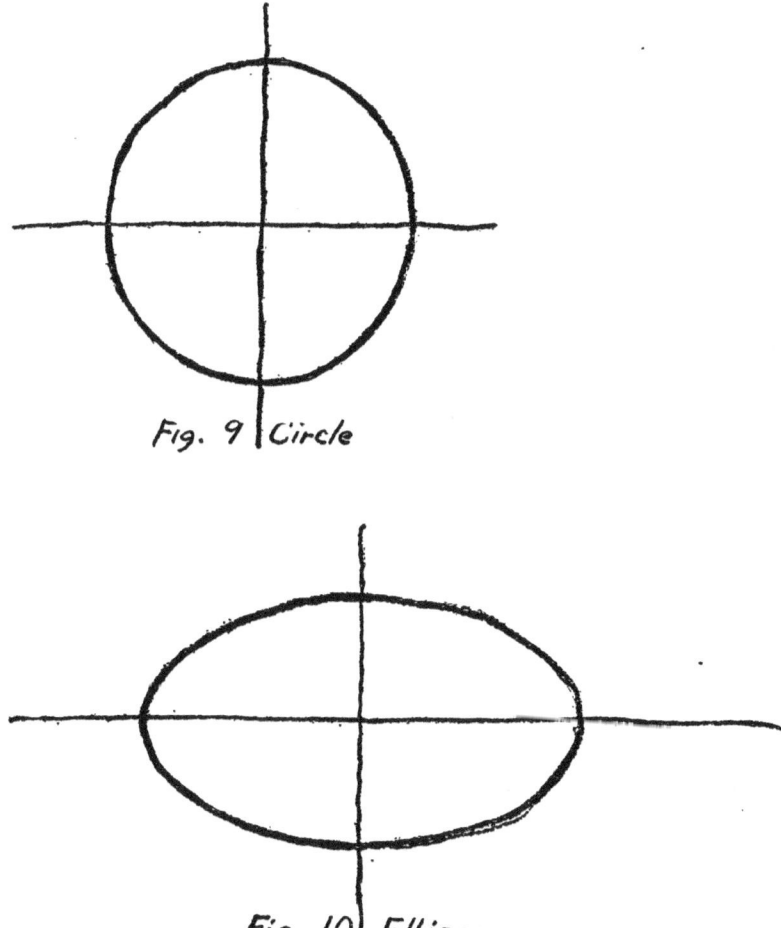

Fig. 9 Circle

Fig. 10 Ellipse

left, then it is not advisable to try to finish the curve beyond the left arm, but it is much easier to change the position of the right hand to a point in front of the left arm and then resume the curve until the starting point is reached. The main disadvantages of this

method are the necessity of having a round object on hand of a size suitable for the circle to be drawn, and at best such a circle will not appear very smooth, due to the necessity of tracing it from point to point, and thus losing the correct direction of the curve in that process. Its advantages are the simplicity and saving in time, especially where only rough sketching is required.

For circles of a relatively larger size, from 2 to 5 inches in diameter, we can use the method of turning the paper about a point fixed by the right index finger, provided the paper is free to move and is not too large to make its motion clumsy or uneven. The pencil is firmly grasped between the right thumb and the forefinger, and the index is extended pressing the paper as a fixed pivot, about which the paper is slowly turned from right to left, or in a counterclockwise direction. The pencil resting lightly against the revolving paper will describe a nearly perfect circle if the fingers are held in place during the complete revolution of the paper.

It is evident that this is a very crude method, depending upon many unreliable factors, but it has the advantage of not requiring any special tools except a pencil and a piece of paper.

Another way for drawing a little more perfect circle is to deliberately sweep the pencil in a clockwise direction describing a closed curve approaching a circle as nearly as possible, and then gradually smoothing out and correcting those portions of the curve that seem to be defective, until a nearly correct circle is drawn.

This method requires some skill and a determined, swift movement of the hand, which could be acquired only by long and patient training of the hand and the eye. The main advantages of this method are the good results that are usually obtained, producing a

FREE HAND DRAWING 11

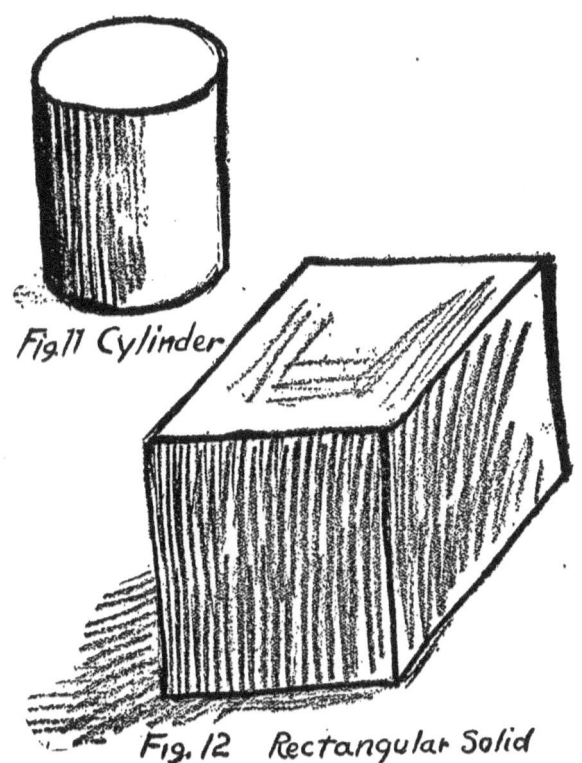

Fig. 11 Cylinder

Fig. 12 Rectangular Solid

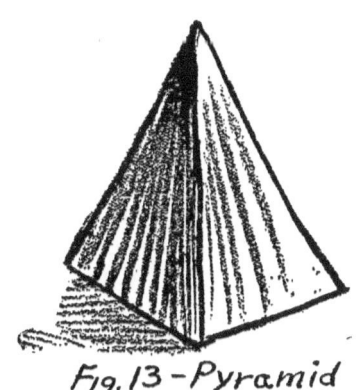

Fig. 13 - Pyramid

smooth and almost perfect circle, and its independence of any variable conditions that would tend to distort the directions of the curve.

The most scientific way of drawing a circle is outlined in Fig. 9, where we first draw two axes at right angles to one another; then the length of the radius of the circle is laid off as equal distances from the point of intersection of the axes in the four directions. It might be of help to draw two more lines at 45 degrees to the first ones, intersecting at the same point, and to lay off the length of the radius upon all these lines. The spacing is estimated by the eye and can be done very accurately after a few trials. Then the points thus laid off are connected with a smooth circular curve, and the whole circle is corrected so as to make as perfect a curve as could possibly be obtained without the use of instruments. The free use of the eraser is strongly advised for this work.

In order to draw the ellipse we must first know the properties of that curve, so as to be able to check our work with the correct curve. The two axes at right angles to one another, as shown in Fig. 10, are the principal lines of the curve. The longer axis, which in this case is drawn horizontally, is termed the **major axis** of the ellipse, and the shorter vertical axis is known as the **minor axis.** If from the upper extremity of the minor axis we are to lay off accurately the length of $\frac{1}{2}$ of the major axis, swinging this arc until it strikes the horizontal line, we will thus obtain two points on the horizontal line, inside of the ends of the major axis. These two points are called the foci of the ellipse. The correct ellipse is then to be constructed in such a manner that the sum of the distances from any point on the curve to the foci is equal in length to the major axis. This principle could be used for checking the freehand curve by means of a compass, until the student is able to

draw the ellipse correctly. In drawing the ellipse without the aid of any instruments we lay off the major and minor axes accurately, estimating the lengths so as to make the figure perfectly symmetrical. This gives us four points on the curve, and these are then connected with the smooth curve, checking the outline by the eye until we obtain the correct elliptical shape. It might be of help to bear in mind that the portions of the ellipse near the extremities

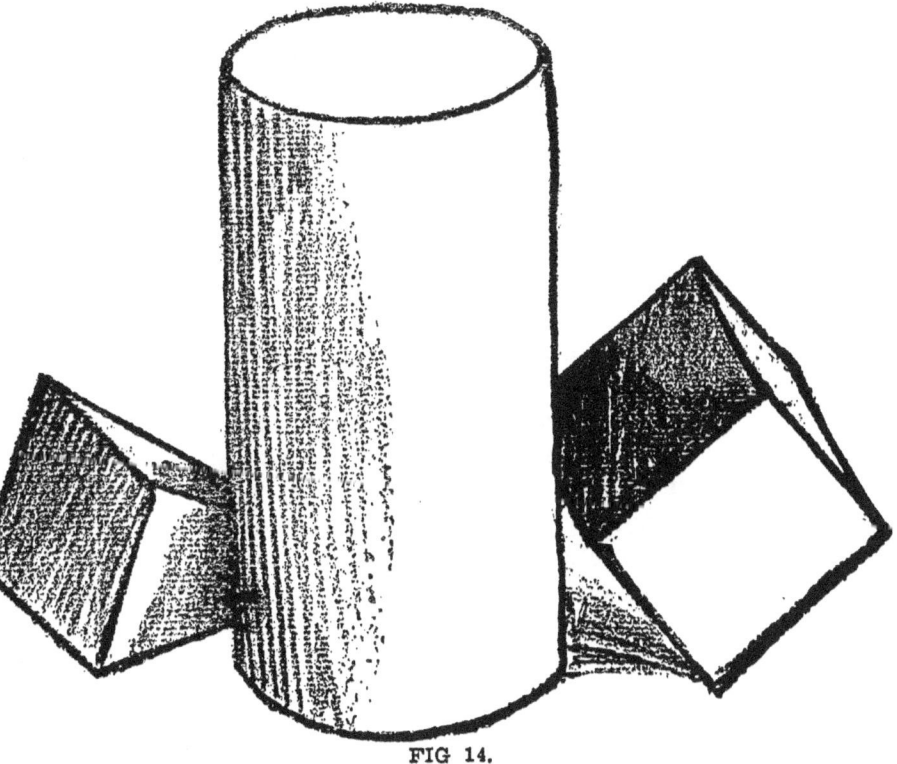

FIG. 14.

of the major axes are very nearly circular, while the portions near the extremities of the minor axes are nearly straight lines.

Drawing From Models.

The principles outlined above will enable the student to make neat sketches of simple solid bodies, such as cylinders, rectangular solids, cubes, pyramids, cones, etc. In order to learn the appearance of these geometrical bodies from different angles it is advisable to obtain some simple models of these bodies and devote some time in copying them in different positions and from different angles. At first it is advisable to draw these solids in their normal positions, such as indicated by the Fig. 11, which is a freehand sketch of the cylinder, Fig. 12 being a view of the rectangular or oblong solid, and Fig. 13, which is a side view of a square pyramid. Especial attention should be given in shading the sides of these figures by either carefully noting their actual appearance in life, or by imagining a ray of light illuminating them at a certain angle.

Referring to Fig. 11, it is important to remember that the top and bottom of the cylinder, although circular in shape, appear to the eye as elliptical, so that in this case the top is drawn as a complete ellipse, having its major axis equal to the actual diameter, while the minor axis is made shorter, the amount of shortening depending upon the relative position of the observer and the body. The bottom is drawn as a half of an ellipse, equal in size to the one at the top. The light is assumed to come from the lower right hand corner, so that the left portion of the figure is shaded, the degree of shading varying from heavy to light as we proceed towards the right.

In Fig. 12, representing the rectangular solid, care should be taken to make all the edges as near parallel as practicable. In Fig. 13 the pyramid is placed in such a position that only two of its triangular sides

FREE HAND DRAWING

are in view, the slope of the lines at the bottom depending upon the angle at which the observer is placed in relation to the body.

Fig. 14 is a combination of a cylinder (upright), and on the left a square pyramid lying flat on one of its sides, with its bottom exposed to view, and its top hidden behind the cylinder, and to the right we have a cube partially hidden behind the right edge of the cylinder. The student is advised to make this exercise by arranging the models in the same manner and drawing the figure without referring to the illustration here shown, then comparing the result with Fig. 14. Then the models are to be removed and the same arrangement is to be drawn from memory, including the shading. This will enable the student to grasp the idea of the true representation of objects as they appear to our eye, and will lay the foundation for the more advanced free hand sketching, either from life or from memory. It might be advisable to mention here that the beginner is warned to proceed with the above exercises very slowly and in their logical order outlined above, being careful not to begin the work of any new figure until the preceding exercise has been thoroughly mastered in every detail.

CHAPTER III.

Geometrical Bodies.

The representation of geometrical bodies in space requires a good deal of skill which could be acquired only after a systematic course of study based upon careful observation of the appearance of objects in nature. As suggested in the previous chapter, the student is strongly advised to make use of constructed models in going over the following exercises. By rearranging these bodies in various positions with respect to one another and to the horizontal plane, we can produce as many combinations as we desire, thus making a practical study of the actual appearance of these bodies from different angles and with different shadings.

Referring to the group of bodies shown in Fig. 15, we have here three geometrical bodies:—a cube, a cylinder and a triangular prism. The cylinder is shown standing upright with the cube tilted and leaning against the back part of the cylinder, towards the left, and the prism is shown in front of the cylinder lying flat on one of its sides at an angle, and one of its edges just touching the forward portion of the cylinder.

In order to draw this position correctly with the least trouble, it is advisable to begin with the cylinder, since this is the central figure in the group. First draw the top of the cylinder as an ellipse, determining the correct ratio between the major and minor axes by the eye, remembering that the major axis (horizontal axis) is equal to the correct diameter of the circular top, while the vertical axis is the one that is

foreshortened. After sketching in very lightly the four extremeties of these axes and the other principal points on the curve, the ellipse is then drawn in heavier lines, forming a smooth and symmetrical curve. Then the edges of the cylinder are drawn as plain vertical lines, and both the top and the lateral surfaces are shaded towards the left, since the light in this case is shining from the lower right hand corner of the plate. (See Fig. 15).

The next step is to draw the prism, beginning with the forward face in its correct relative position and without any shading since the light is shining right upon the surface. Then the face of the prism which is away from us is shown as a rhomboid with one side elongated and the other side shortened, since that would be its natural appearance to our eye. That side is shaded quite heavily, and its shadow is slightly indicated falling upon the forward left portion of the cylinder.

The outline of the prism is now completed by finishing the third side of the triangular end, which is shaded towards the left due to its inclination to the rays of light.

The cube which is partially covered by the cylinder is then drawn, beginning with the face nearest to the cylinder, this face receiving the shadow thrown upon it by the cylinder. Then the bottom of the cube is drawn with two of its edges parallel to the corresponding edge upon the top of the front face, and the left edge of the bottom making the proper angle with these parallel edges. The bottom is heavily shaded, and so is the space between this bottom and the cylinder since the rays of light do not reach into that portion of the group. The outline of the cube is finished by drawing the left face as a rectangle having all its sides parallel to the corresponding edges of the other

face that has already been drawn. The left face of the cube is not shaded since it presents all of its surface to the light. -

By carefully examining Fig. 15 the student will observe that the shading is made according to certain definite principles which could easily be acquired by following out each portion of the figure with reference

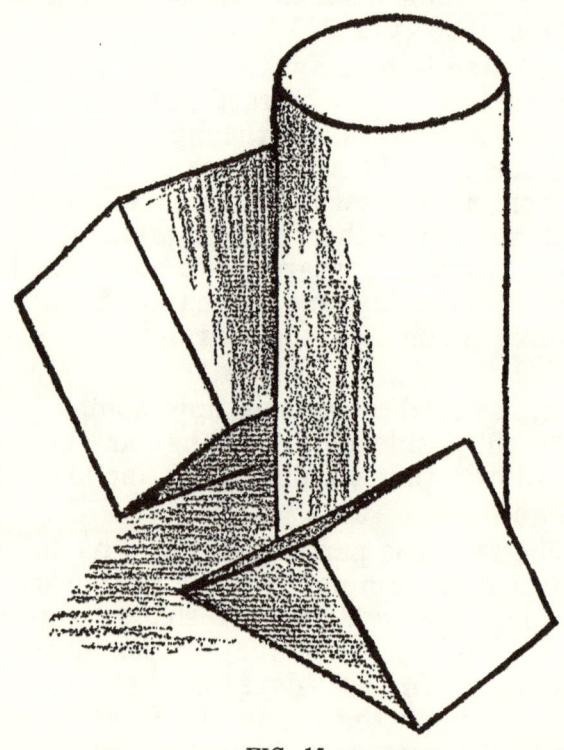

FIG. 15.

to the source of light. It is also clear that the proportions of the bodies as shown in the drawing are very much distorted from their actual measurements since by observing an object from a certain angle we see some lines longer and other lines shorter than they actually exist in space. To illustrate this, let us

FREE HAND DRAWING

imagine that we are looking at a straight line placed vertically at a certain distance from us parellel with the vertical axis of our body. We then see it as a vertical line in its correct actual length. Now, if we were to tilt this line forward or backward, we will get the impression that this line is still vertical if we have not moved it to the right or left, but the line will appear to our eye a good deal shorter since due to the tilting the upper end of the line is vertically nearer to the lower end. By tilting the line more we see it getting shorter and shorter, until when we get the line in a position at right angles to our body, all we can see is the point of its nearest end, and if we look straight at the line we cannot tell whether it is a line or a single point.

In the same manner we can look straight at a circle placed with its plane parallel to our body, and then we see it in its actual circular shape. But if we revolve the circle about its horizontal diameter, we will get the impression of an ellipe, the major axis being equal to the horizontal diameter, and the minor axis being the vertical distance between its upper and lower edges. It is evident that the more we tilt the circle, the shorter will be the appearance of the vertical axis of the ellipse; and if the circle is placed with its plane at right angles to our body, the circle will then give us the impression of a straight line equal in size to the diameter.

From the above illustrations it is evident that the amount of distortion of an object as it appears to our eye bears a direct relation to the angle at which we observe it, and in each case the proper shortening or lengthening of the lines can be correctly determined by the analysis as outlined in the above two cases.

This process, however, is rather tedious and requires a lot of valuable time, so that in this free-hand work

the students are not expected to perform their work in such a manner.

The easiest and quickest way is to get the proper amount of distortion from practical experience with models; but the principles underlying the causes for such distorted proportions should always be kept in mind as a guide and a check to the practical execution of the work.

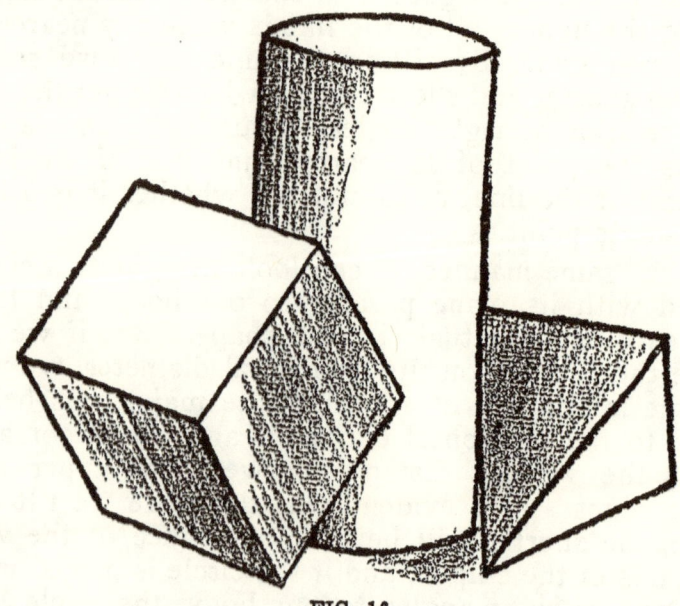

FIG. 16.

Fig. 16, representing another arrangement of a cube, a cylinder and a square pyramid, will furnish additional suggestions for arranging the models and for proper shading. The students are advised here to carefully distinguish between the **shades** and **shadows** in these figures. By the shade of a body is meant the darkened portion of the surface of the body due to the more or less partial obstruction of that part from the direct rays of light. By the shadow is meant the darkness produced upon the surface of a body due to

FREE HAND DRAWING 21

the obstruction from the rays of light by some other body placed in their path. Thus, in Fig. 16, the upper portion of the cylinder shows the shading, while the

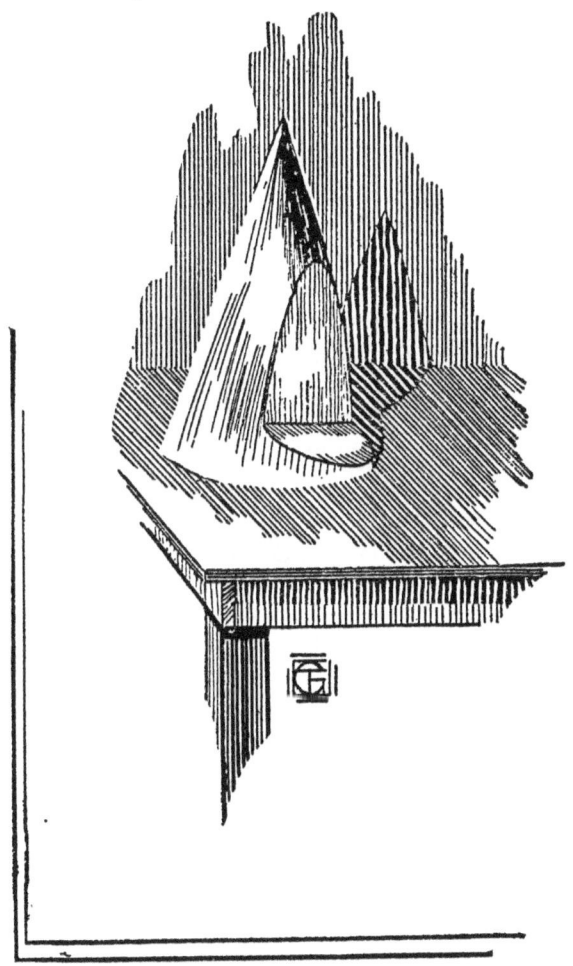

FIG. 17.

part near the bottom of the cylinder is the shadow cast upon the ground and upon the cylinder by the pyramid. Both the shades and shadows must be included in any complete freehand sketch to make it appear

more natural and true to the appearance of the same bodies in life.

As an illustration of fine work in shades and shadows we have the free-hand sketch in Fig. 17 showing the appearance of a cone, with two sections made in it, one parallel to its vertical axis resulting in the shape of a parabola, and the other section taken at an angle between the horizontal and vertical planes, giving the shape of a portion of an ellipse. The cone is here represented standing upright upon a table, the shadow of the cone falling to the right, partly upon the back wall, and partly upon the surface of the table. The source of light in this case seems to come from the lower left hand corner, so that the shading of the object, wall and portion of the table is heavier towards the upper right hand portion of the sketch. Attention is also called to the fact, that all the shading is done here by straight lines varying in density and in direction according to the requirements, and the outline of the objects being produced by the shade lines themselves meeting one another, as would be the case with the appearance of objects in nature. Such shading is very often made with the help of a straight edge, and gives excellent results if the available time allows such refinements.

CHAPTER IV.

Perspective Drawing.

In order to represent objects exactly as they appear to our observing eyes we must take into account the peculiar optical illusion that distorts the proportions of the bodies when placed at an appreciable distance from the observer. In case the body is placed far from the eye it appears a good deal smaller than it actually is, the amount by which the size seems to be diminished being directly proportional to the distance between the object and the observer. Thus when a train moves away from the observer, the last car seems to get smaller as the train moves farther away, and when the car is twice as far from the observer than it was when he first looked at it, its size appears about one half of what it seemed to be at the first observations.

By looking at a long object that stretches quite a considerable distance directly in line of observation, the front portions of that object will appear a good deal larger than the parts that are at the farther end. Such is the common experience with views of long buildings, streets, rows of trees, posts in line, and similar objects that are made up of similar parts arranged along definite straight lines.

To illustrate the simplest case of this effect we have the sketch in Fig. 18 of a bookcase lying flat on the floor, away from the observer who is looking down upon it, but not directly over it. The front portion of the bookcase nearest to the observer is drawn a good deal larger than the rear end, and the sides are made to slope gradually from the larger to the smaller rect-

24 FREE HAND DRAWING

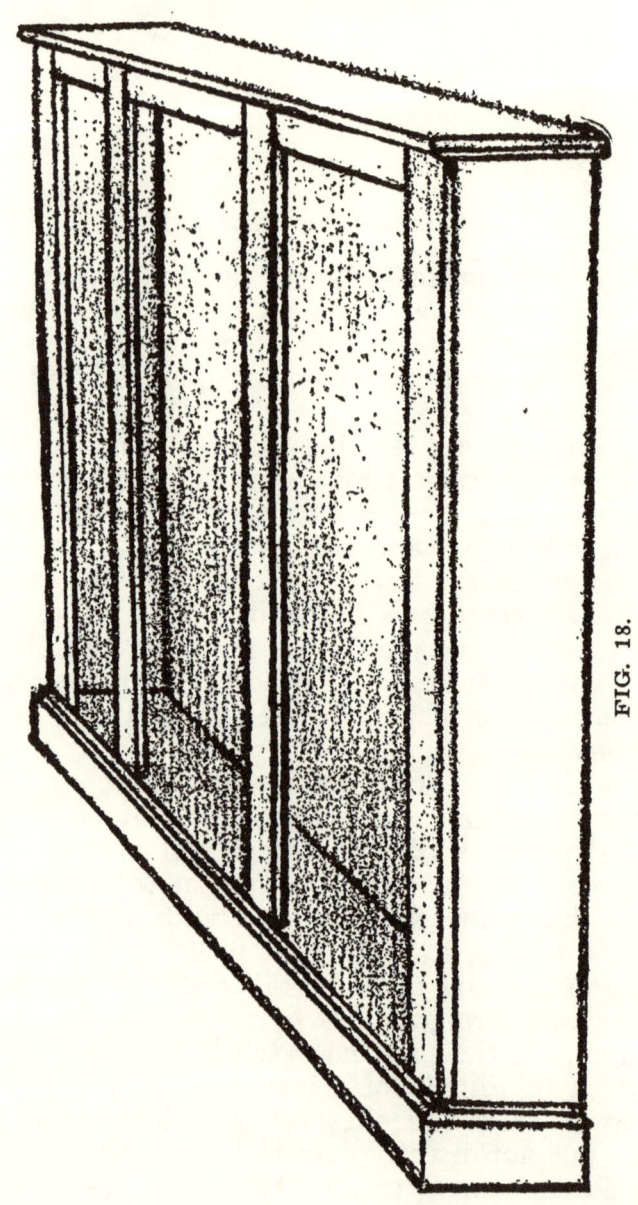

FIG. 18.

FREE HAND DRAWING

angular shape. Following the same idea, the distance between the first shelf and the second one is shown proportionally greater than the distance between the second and the third shelf, etc. It is important to notice the widths of these shelfs are drawn unequal, getting gradually smaller as we go from the front view to the rear. All the other portions of the bookcase are drawn along the same lines which are not parallel but all slope towards some imaginary common point of intersection, which is known as the **vanishing point** of the picture. By holding this sketch at a distance from the eyes equal to about the length of the arm, the reader will observe that the impression given by this sketch is of an object having all its edges perfectly parallel, although by examining it more closely we can see at once that they are far from being parallel. Such a method of representing solid bodies is known as **Perspective drawing**, and is used a great deal in many cases by engineers, artisans, mechanics and architects.

The correct methods used in representing a simple object by means of perspective drawing is illustrated by Fig. 19, which shows the outline of a house drawn by the observer standing at the one of its corner at some distance and a little above it so that he could get the full view of the walls and the roof. In this case use is made of two vanishing points, marked **A** and **B** respectively. Each of these vanishing points is used for each of the two walls visible to the observer, since he gets two directions in which the lines of the object seem to converge into single points if they were continued far enough. All the parts of the building are drawn in the same manner getting smaller and nearer to one another as we go from the nearest corner to the far ends of the building.

The sidewalks are represented in the same manner, so that by looking at Fig. 19 at a distance we get the

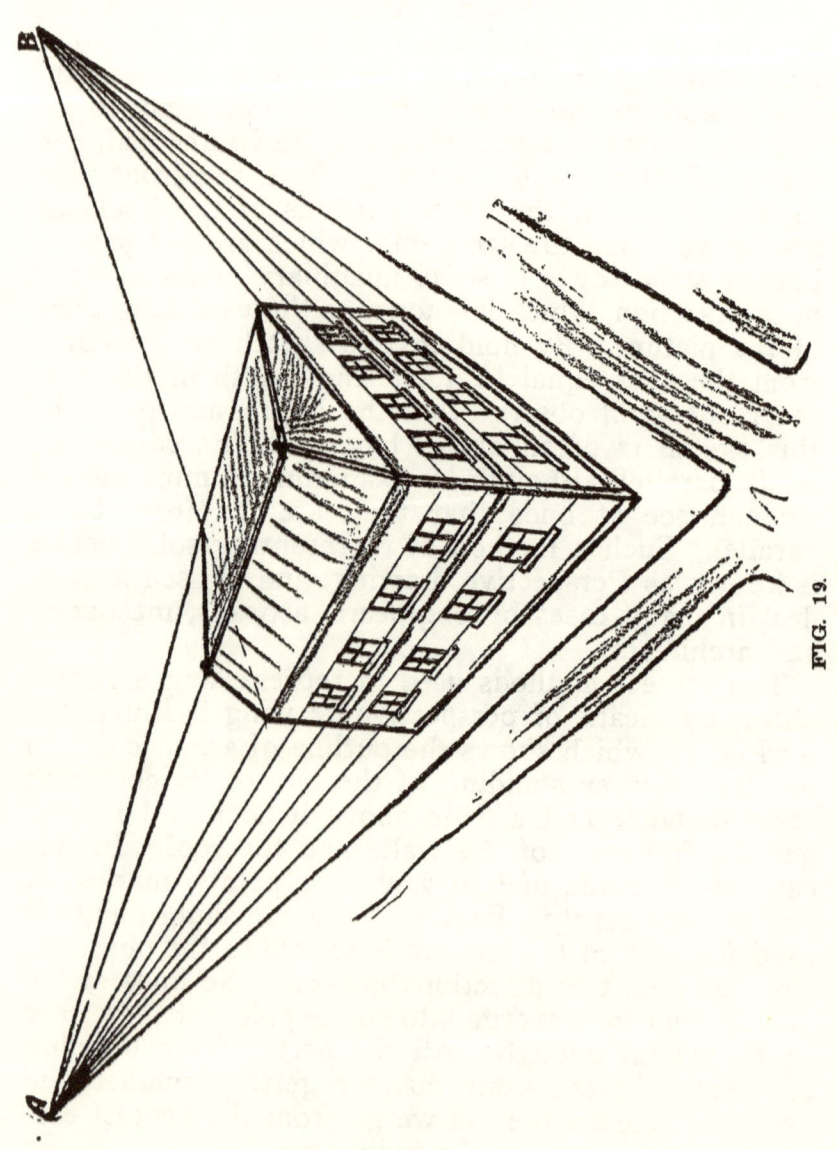

FIG. 19.

impression of the actual building as it appears to our eyes under similar circumstances.

Fig. 20 illustrates the same principles of perspective

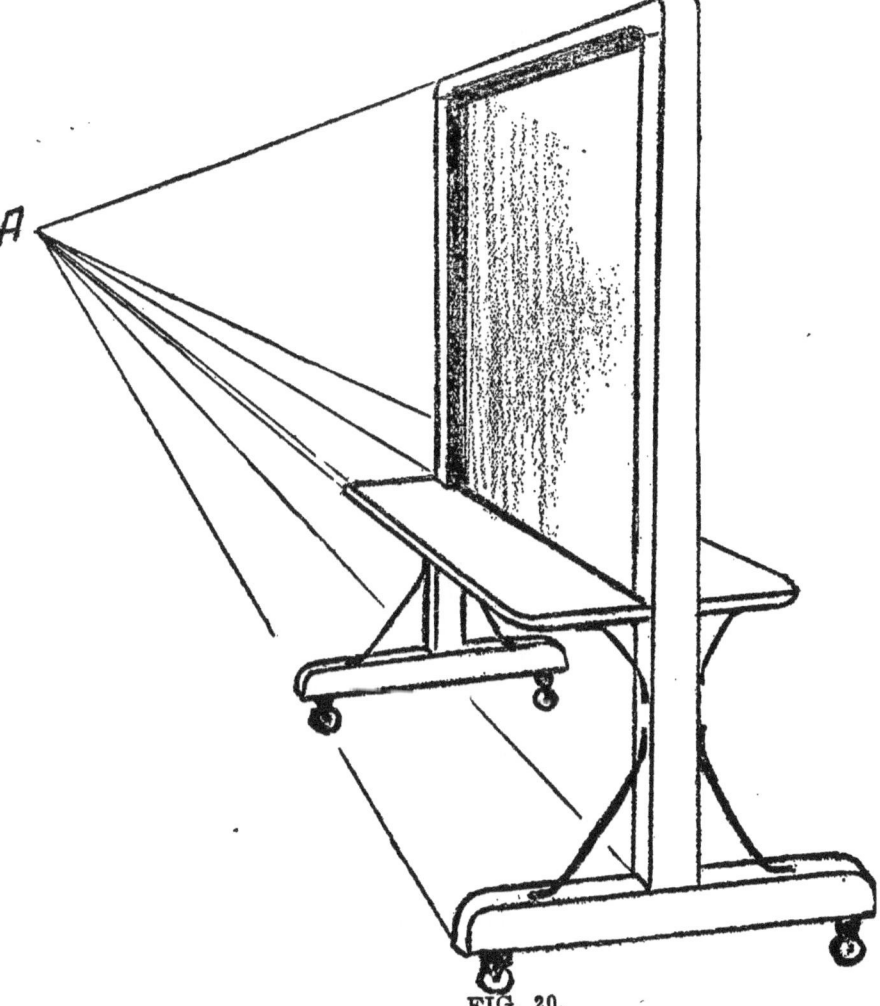

FIG. 20.

applied to an object having several curved lines as well as straight edges. The portable blackboard shown here has rounded corners at the bottom pieces

of the supporting frame, also some rollers and curved iron rods to support the brackets and to stiffen the wooden frame. All these curves are drawn out of actual proportion, but in the correct ratio of the distance of each point from the observer, the whole system of lines converging towards the single vanishing point A. This sketch is made still closer to actual appearance by the shading of some portions of the frame and very light shading of the visible portion of the board itself.

In drawing any object by the above method it is best to observe closely the apparent angle which the lines of the object make with one another, and then lightly sketch in these outlines, changing them until the correct vanishing point is finally located. Then the main outlines are marked off along these vanishing lines keeping all the vertical directions straight up and down and parallel, since in ordinary cases the vertical distances are not far enough to be represented at a distorted angle. The distances along any of the vanishing lines are then laid off in the proportion of the location of the points from the observer, the largest distance being directly in the front view, and the smallest distance being the last one near the vanishing point. This does not have to be made correct in such proportion, since it is only important to produce the general impression rather than make an exact layout, which could only be accomplished by means of drawing instruments and many computations. In ordinary cases the sketch is laid out roughly, aided only by the experience of the trained hand and the judgment of the eye.

CHAPTER V.

Technical Illustrations.

In this course of free-hand drawing we have so far presented all the important theoretical elements necessary for the production of a correct sketch. Beginning with the simple exercises of the straight lines and elementary curves we have taken up the questions of drawing solid objects, the rules for shading and the principal requirements for perspective drawing. These exercises will enable the student to make a neat and accurate sketch of a simple object.

We will now endeavor to take up the practical applications of the above principles so as to present a concise course in technical free-hand work used for making simple illustrations or rapid sketches of actual pieces of machinery or apparatus, taken in the field and used later for a more careful drawing to scale by means of instruments.

In this work we can freely use the rule for making straight lines, since in case of practical drawing of this kind the straight edge is invariably used in one form or another.

We will first discuss a few typical examples of more or less elaborate free-hand drawings that are to be used as **technical illustrations** rather than working sketches; or, in other words, we will study how to make a neat-looking free-hand drawing of some technical appliance to be used for illustrating a catalogue, an advertisement in a technical magazine or an engineering paper of any kind without giving any exact dimensions or details, but presenting a general

idea about the appearance or arrangement of the particular part that we wish to describe.

Such illustrations are often made purely from the imagination or by memory without the aid of any models or drawings of any kind. But it is more common and advisable to have either the object or a reduced model of the part to be illustrated in front of the sketching pad, so that the drawing is made more accurate with the proper shading and the different portions of the objects shown in their correct relative proportions. In case the object is not available or is too large, and a model is too expensive or could not be obtained for any other reasons, the next best thing to do is to make use of a photograph showing several views of the object to be represented. From these photographs we can form a clear idea of the exact construction of the part in question, and after eliminating all the unimportant details and outlining the main features we can draw the object with its essential details so as to bring out more forcibly certain parts which we wish to emphasize, and to eliminate all the features which are of secondary importance and are liable to confuse the reader.

Referring to Fig. 21, we have here a sketch of a wooden pattern for the main casting of a dynamo-machine. This is drawn from the full-sized pattern placed at such an angle that all the main features of the pattern are well illustrated such as the circular magnetic frame, the supporting plate, the two end pieces and the poles attached to the interior portion of the frame. The drawing also shows the location of the lines of splitting the pattern both horizontally and vertically, also the smaller details such as lugs, grooves, ribs, etc.

In laying out the above sketch we first determine the axes of symmetry of the whole figure, which in this case are the axes of the ellipse representing the

FREE HAND DRAWING 31

outer edge of the circular frame. These lines are drawn in very light, the vertical axis being a vertical line, but the horizontal axis drawn inclined lower to the right, making an angle of 15°-20° to the horizontal line. Then the width of the framing is lad off horizontally at the top, and the two ellipses are drawn in according to the methods outlined in the previous

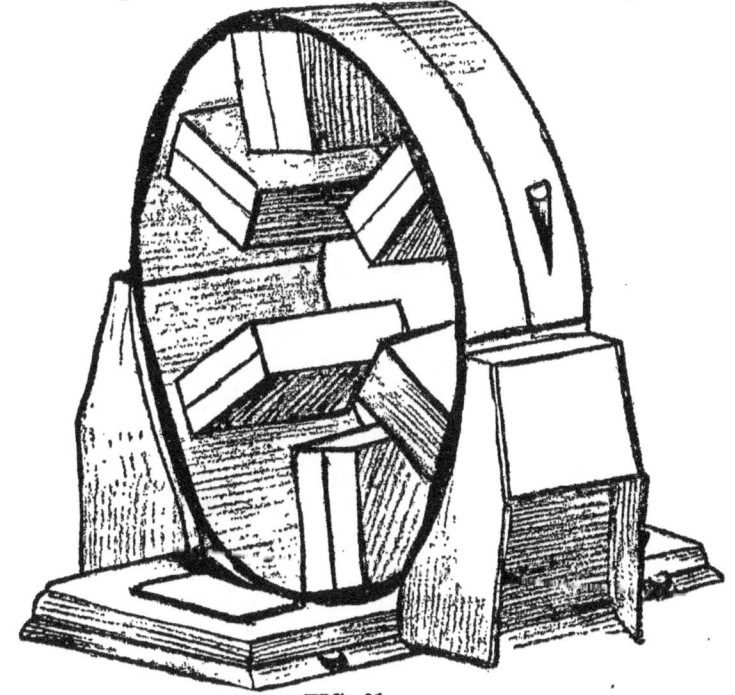

FIG. 21.
PATTERN OF DYNAMO.

chapters. Only those portions of these ellipses are shown that are actually visible, but the outline could be made with ellipses complete in very light lines, and then the portions that are visible are gone over with firmer lines, while the invisible parts can be erased.

The supporting plates (see Fig. 21) are then drawn by means of the rule and pencil, care being take to

make the opposite edges nearly parallel or gradually and very slightly converging towards the background to give the correct perspective view. The end pieces of the framing are next drawn making one edge of the piece parallel to the corresponding edge of the supporting plate, and the other edge, placed at an angle of about 120° from the first one, which will give the impression to the eye of a right angle.

In following up this sketch (Fig. 21) it is important to note that all the main straight outlines are drawn along three principal directions, one being exactly vertical and the other two making an angle of 120° with the first one. This method of representing objects approaches very closely to the natural appearance of any object to the eye and it is known as the **Isometric Projection**. It is used a great deal in cabinet-making, sheet-metal work and all similar cases where all the three directions are represented in the same view.

The pole pieces in Fig. 21 are in each case drawn at right angles to the interior of the framing, and the drawing is then completed by adding the smaller details and by proper shading so as to indicate the light shining from the lower right-hand corner. We must also consider here the shadows thrown by one part of the machine upon the other, as well as the shadows thrown by these parts upon the base of support or the other objects in the immediate vicinity. Every portion of this sketch must be gone over carefully several times by the aid of the eraser and pencil until each one is neat and accurate and the whole drawing gives the correct impression of the appearance of the machine.

Fig. 22 is a somewhat similar sketch of a special electrical fitting intended particularly as an illustration for an advertisement showing the main points of connections and a portion of the interior arrangement for contact.

FREE HAND DRAWING 33

The main body of the fitting (see Fig. 22) is made up of a cylindrical receptacle provided with circular base having four projecting pieces attached to it for support and also for making the necessary connections. The top of the fitting being open and of circular shape

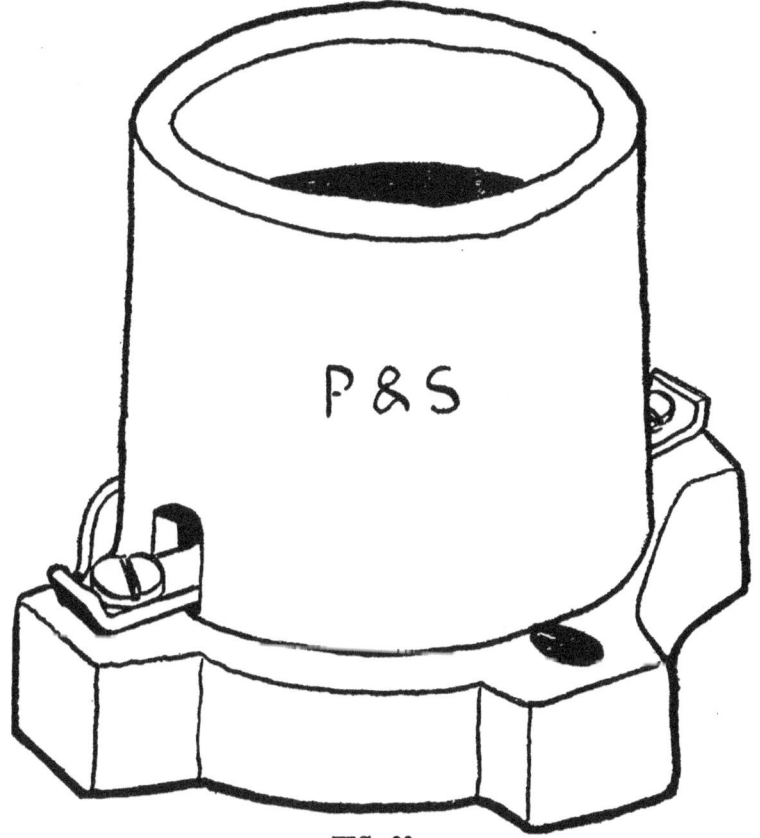

FIG. 22.

is indicated by means of two ellipses, the distance between these curves corresponding to the thickness of the wall of the appliance. Inside of this hollow cylinder there is a portion of another ellipse shaded very heavily to show the metal connection visible at that point.

Special stress is laid upon the connection lugs and screws, since these form one of the features of advantage of this particular electrical specialty, and these are shown very prominently and shaded with particular care to bring out these parts clearly. The outline of the base is made partly cylindrical and partly rectangular according to the location of the particular part, since the space between the four projecting pieces is made up of arcs of a circle of a radius somewhat larger than the outside radius of the top portion of the fitting.

The shading in Fig. 22 is very simple, since the whole figure is symmetrical about a common vertical axis, and all the shade lines are practically all vertical.

The lamp drawn in Fig. 23 illustrates the method of drawing an object entirely without any sharp outlines but merely by the aid of shade and shadow lines.

For this sketch we have to make use of the pencil-compass as well as of the straight edge, but any lines drawn in that manner are used merely as guide lines and are later erased in the course of shading, so that the whole sketch when finished has no sharp lines but very carefully drawn shade lines of varying strength and spacing according to the amount of light or shadow we wish to indicate at any particular point. Such a method of free-hand drawing can be acquired by the aid of frequent exercise with models and objects placed at different positions with respect to an actual source of light.

Another type of technical illustration used a great deal for catalogues is shown in Fig. 24, which is a rough sketch of a certain type of mast jib-crane showing its general construction, method of support and its relative position with respect to other objects.

The lines are drawn with the aid of a rule, and the principles of isometric projection are employed here so as to show the view of the steel members making up

FREE HAND DRAWING

the framing and the appearance of its upper and lower supports. The traveling trolley riding on top of the channel frame is indicated by its circular wheels and a few main lines of the casting that forms the carriage of the trolley. The hoisting chain, block and hook are indicated roughly, giving none of their details, but presenting the appearance of the complete equipment in a general way.

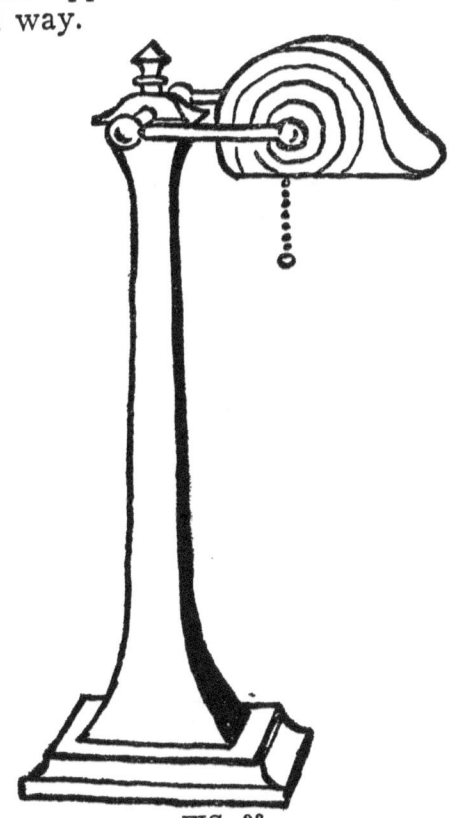

FIG. 23.

Such sketches are usually supplemented with notes giving the names and the directions for each part of the mechanism as well as the principal dimensions, so that by the aid of such a rough free-hand sketch, we have a clear idea as to the operation of the machine

36 FREE HAND DRAWING

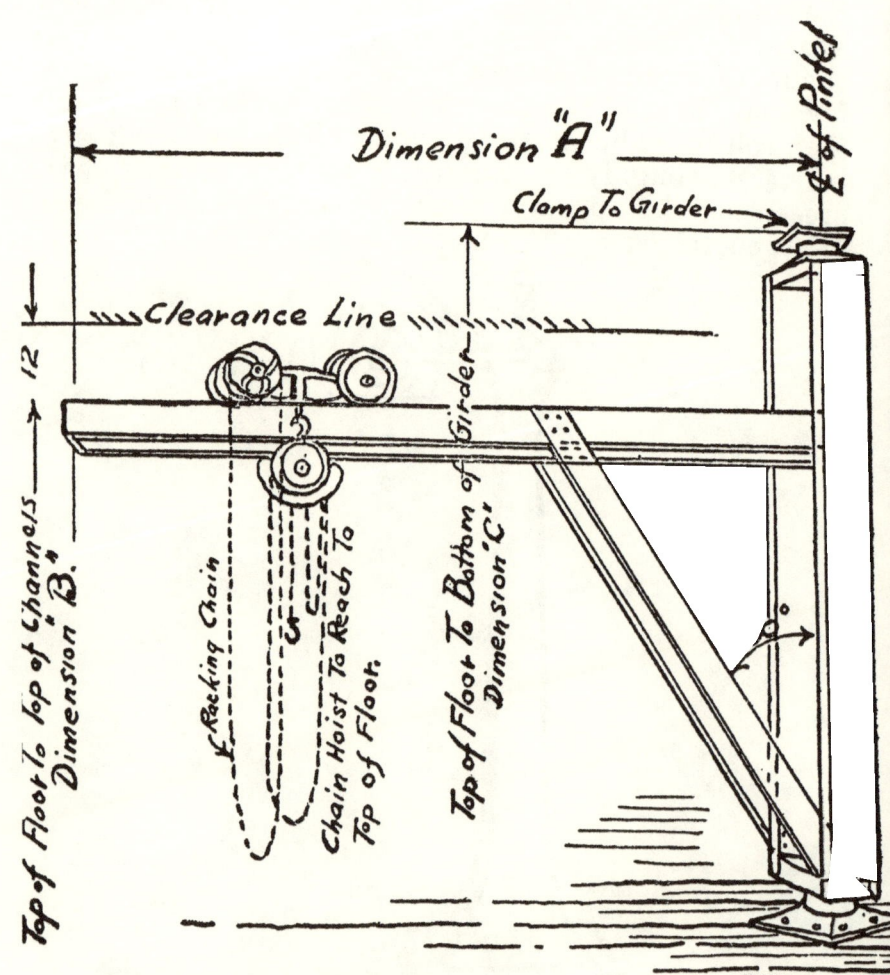

Under-Braced Mast Jib Crane With 4 Wheeled Trolley on Top & Chain Hoist.

FIG. 24.

FREE HAND DRAWING

and the space it would require, giving us enough data to enable us to make an exact working drawing of the same machine, to scale.

The shading of this drawing is similar to those discussed above, including the shadow lines at the lower support of the crane.

In all the above types of technical illustrations our first object must be borne in mind, and that is to present the sketch in such a manner that the reader can get a clear idea of the general construction as well as the appearance of the particular machine or equipment which is illustrated so that the main features could be grasped at once without requiring any long description by means of text. An illustration of this kind if neat and accurate will convey more information at a glance than volumes of writing and it will be found of great value to both the designing engineer and the sales manager of the machine.

CHAPTER VI.
Technical Sketching.

The practical application of the principles of freehand drawing to purely engineering work is especially important in making rapid sketches of either objects existing on a particular job to be investigated or of work to be contemplated in the future. There are many occasions in the daily experience of every engineer or any man connected with engineering work when he is called upon to represent an object in its correct relation to other things, making a rough outline and giving all the necessary dimensions or other notes of information. This is usually required to be made in a short period of time under circumstance which would not permit of the elaborate use of a board, T-square or drawing instruments so that the drawing is made absolutely free-hand, with only a pencil and a scrap of paper, and with no means for supporting the sketching paper except an occasional back of a book or a wooden board. There are moments snatched while traveling on the train when an idea presents itself to the engineer about the job, which he wishes to preserve at once for future development. Then he has to use any chance scrap of paper such as a back of an envelope and a stub of a pencil to illustrate his idea with an accurate sketch, which would be intelligible to himself and others when the occasion arrives for making use of it. In all such cases of emergency the modern engineer must train himself to make these sketches rapidly, yet as neatly and accurately as the occasion might require.

In the first place it is very important for every technical man to have with him as part of his daily

FREE HAND DRAWING 39

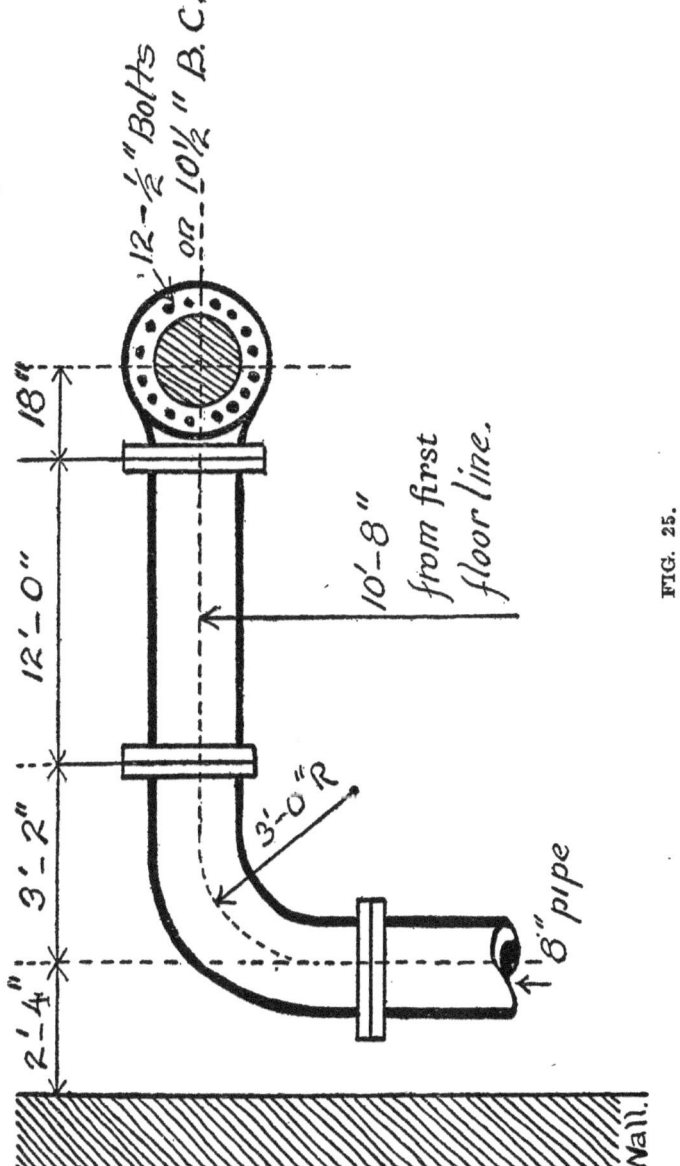

FIG. 25.

equipment some kind of a memorandum book of a size convenient to be carried in the pocket, yet sufficiently large to allow enough space for notes and sketches. A loose-leaf form is to be recommended since the leaves can later be thrown away after they have been copied in a more permanent form and they can then be replaced by new ones at very small expence.

It is preferable to have at least part of this notebook made of cross-section paper ordinarily used for figuring, since these equal divisions will then serve as a rough guide for straight lines and for the general symmetry of the sketches, and this paper can also be used to greater advantage in making computations.

The sketches can be made either representing the objects as they actually appear to the eye as illustrated in the previous chapters, or we can make use of the ordinary rules of projection, which allows the accurate representation of those views of the body with which we are concerned leaving out all other details which would not add any information.

To illustrate some of the typical sketches made on the job, let us examine the rough outline of a piping connection shown in Fig. 25. At a glance we can note that this pipe has two right-angular turns, one from vertical to the right and then from the right to the front. The first turn is accomplished by means of a long-radius elbow, having a radius of 3 feet, and the second turn is made by means of a standard elbow its forward flange facing the observer and having 12 bolts spaced evenly around a $10\frac{1}{2}$-inch bolt-circle. These two elbows are connected by means of a 12-foot-straight piece, and all the connections are made by means of flanged joints bolted together. We have here the main dimensions of these fittings, the size of the pipe, its distance from a wall and the height of

FREE HAND DRAWING

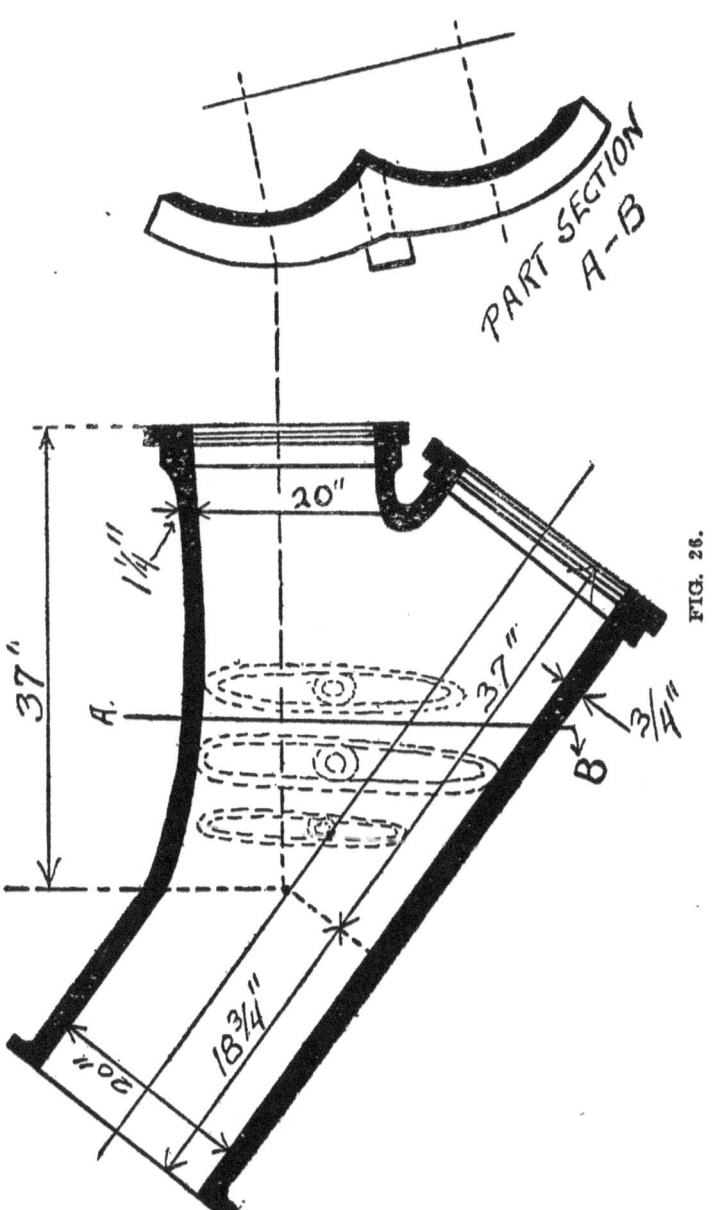

FIG. 26.

the horizontal run above the first floor of the building. This amount of information seems to be sufficient for building the whole portion of the piping, for locating it correctly to scale on any drawing or for reporting the condition as it exists to the man in the office who is interested in that particular information. Such a drawing is a correct picture of the appearance of the piping as well as a projection drawing since it is the front elevation of the pipe with its lower end cut off and the front portion disconnected. Such a sketch can easily be made in 5 or 10 minutes. The usual procedure is first to draw the whole view of the piping in the right proportion, not attempting to make perfect lines or curves but using enough care so that the general appearance conveys a clear idea of the object. A little shading will greatly help the impression and should not be omitted in any of these sketches. Then the measurements that would be required are decided upon and the proper lines and arrow-points are drawn in so as to be certain that none of the measurement would accidentally be omitted. Great care must be taken to place the arrow-points so as to clearly indicate the points between which the measurements are taken. Then the actual measurements are made and are noted as fast as they are obtained, none of them being kept in mind for any length of time before being noted, thus avoiding the chance of forgetting them or confusing them with others. Each dimension should be carefully checked by adding or substracting from some other point of reference, such as a wall, column, etc. After all the measurements are noted and checked, the whole job must be given a thorough inspection and all information relating to the purpose on hand should be clearly covered by notes on the same sketch unless these notes are so large as to require a separate page.

This rough and ready method of drawing is used

FREE HAND DRAWING

not only for engineering objects that are already in existence, but also for designing things that exist only in the mind of the draftsman. This is done so as to represent the idea rapidly in a more concrete form before attempting to draw it to scale. Fig. 26 represents such a rough design of a cast iron Y-branch as it appears to the draftsman before the actual detailed drawing is made. It contained one full longitudinal section of the fitting and a partial section showing all the important features of the piece and giving only the principal dimensions for preliminary computations. After these dimensions are checked and somewhat modified by computation, then the same piece can be laid out to scale and it can be detailed to suit the particular requirements. These preliminary sketches are very valuable for future reference and should be carefully filed for permanent record. In Fig. 27 we have a case of structual detail where the notes are more valuable than the dimensions, since in this case the parts of the steel structure are made of standard material and as long as the size of the I-Beam angle or channel is noted we can easily find all their other, dimensions or properties from any handbook of structual steel shapes. The two important dimensions that would be essential in such work are the horizintal spacing of the 12-inch I-beams and height of the concrete slab above the top of the beams. This sketch is not complete in itself since it does not give the length and arrangement of the above members in plain view or in horizontal plane, but it is sufficient for the purpose of illustrating the construction of a particular section of the building.

In making sketches of electrical wiring such as shown in Fig. 28, we hardly need any dimensions, under ordinary circumstances, except the size and location of the switchboard panel. The purpose of this sketch primarily is to show the relative location of

44 FREE HAND DRAWING

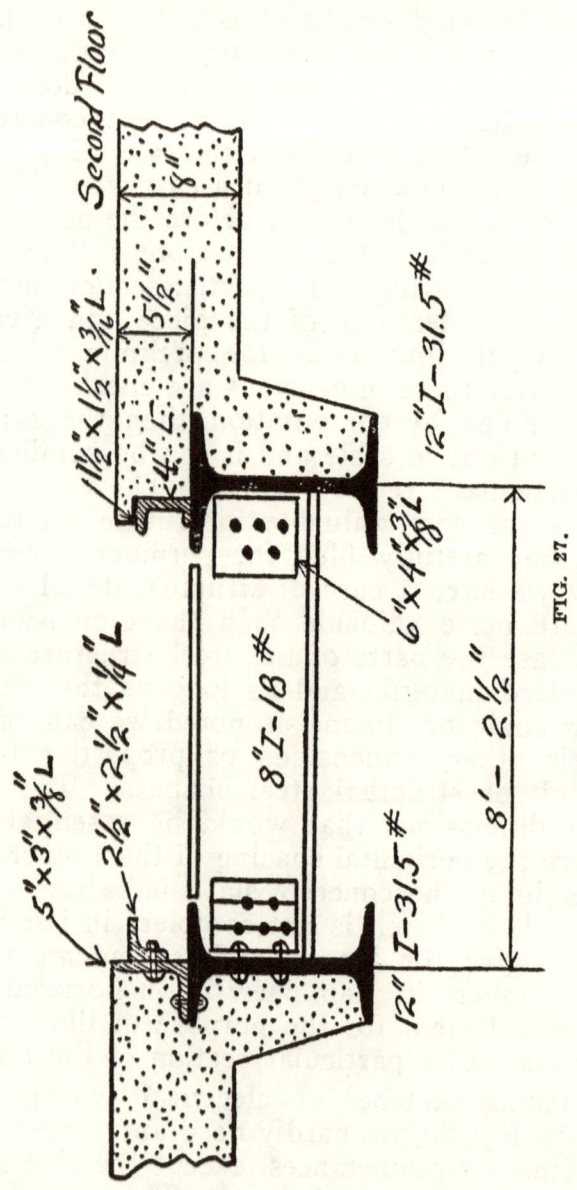

Fig. 27.

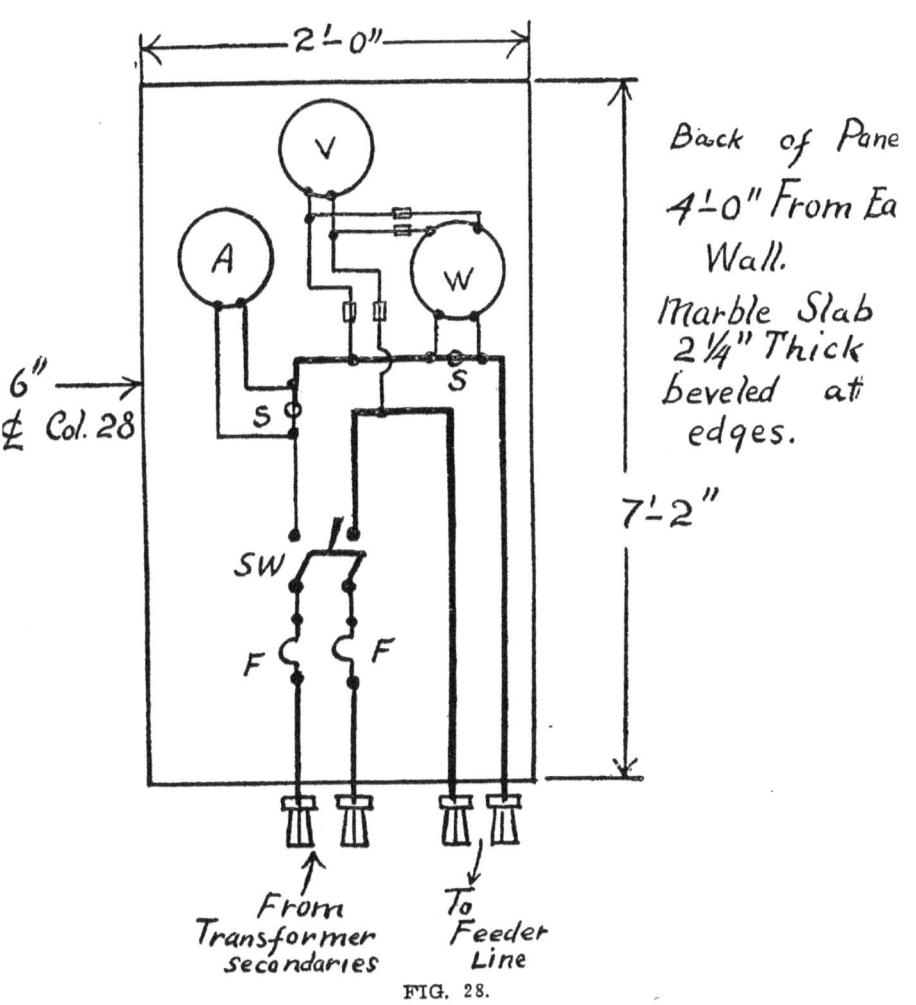

FIG. 28.

instruments, switches and fuses on the board and their connections on the panel as well as to the main incoming and outgoing conduit lines. It is customary in all such electrical sketches to distinguish between the heavier and lighter wires or cables by means of correspondingly heavier or lighter lines on the drawing. The panel is usually sketched from the rear showing all the back wiring but also outlining the instruments, switches and all other equipment in their proper places, although they are actually all placed in the front part of the panel. The notes give the location of the switchboard and the character of the material and general construction as indicated in the sketch.

It might be proper here again to emphasize the necessity for training the powers of observation so there should be very little difference between "looking" and "seeing."

This power of observing things is a part of the requirements of the modern engineer and it goes hand in hand with his ability to make good free-hand sketches. In fact, we might say, that by making a great number of free-hand drawings the engineer gets the benefit of a valuable training as an observer, and, on the other hand, by learning proper methods of observation the engineer becomes an expert in making accurate free-hand sketches besides being generally of greater use in the other duties of his profession.

CHAPTER VII.
Engineering Drawing.
By Joseph G. Branch.

In practically all branches of engineering work, drawing is made of extensive use as a medium of expression for the interchange of ideas. So indispensable is drawing in this connection that it has virtually become the engineers' language, without which they would have great difficulty in making themselves understood. Whenever a piece of construction is to be undertaken, no matter whether it be a huge building or a tiny mechanism smaller than a watch, drawings are practically always used to convey to the builder or mechanician the ideas and wishes of the designer. The day of "cut and try" in engineering construction has gone, and the more exact modern methods have come to stay.

This necessity for drawings in connection with all kinds of engineering work has had the effect of standardizing methods of drawing. This has the effect of making the "language of drawing" more readily and easily understood by all who use it. Since all engineers use the same methods in their drawing there can be no doubt as to what is meant by a particular drawing, assuming of course that it has been properly and correctly done.

In general there are two methods which are recognized in connection with drawing for mechanical purposes. These are: 1. Perspective Drawing, and 2. Mechanical, or Projection Drawing.

In perspective drawing an object is drawn as it appears to the eye, and not necessarily as it really is. The fact that bodies do not appear to the eye as they

really are is one of universal experience. The rails on a track appear to come closer together as they recede from the observer, but we know that they are always parallel. Houses seen at a distance appear to be smaller than others nearer at hand, although as a matter of fact just the reverse may be the case. So in perspective drawing this is always kept in mind, and the object drawn as it seems to be.

The value of this kind of drawing depends upon the fact that it conveys to the mind of the observer an idea of what the object shown really looks like. Patent Office drawings, presented in connection with an application for a patent, are frequently made in perspective. This conveys to the mind of the examiner a definite picture of the object in question, similar to what would be obtained from a model.

But when an object is to be constructed it is quite evident that the mechanic who is to do the work will need something more than a perspective drawing. He must know what the object in question is really like in order that he may be able to make it correctly. So for this purpose a mechanical or projection drawing is used, which shows the object as it actually is. To a person who is inexperienced in the use of such a drawing, it will often look very unlike the object which it represents. But experience with mechanical drawings very soon develops in a person the ability to form a mental picture of what the object is like. In other words he learns to "read" the drawing, and so get the information which it contains.

The Mechanical Draftsman.

The necessity for drawings which show what an object is really like, so that it may be made correctly by one who has never seen anything like it before, has produced the profession of the mechanical draftsman. It is the function of the draftsman to make all the drawings necessary for the construction of the

FREE HAND DRAWING

object in question. Suppose for example that some special kind of automatic machine is to be built, nothing like it ever having been made before. The draftsman will usually make what is known as an "assembly drawing" of the machine, which shows the entire mechanism completely assembled. In case such a complete drawing is impracticable or undesirable for any reason, he will make drawings which show the essential parts of the machine, put together or assembled as they be in the completed object.

But the draftsman must do more than this. He must make what are known as "detail" or "working" drawings, for the use of the mechanics who are to make the various parts of the machine. Such work is usually spoken of in the drafting room as "detailing," and consists in making a separate drawing of each individual piece or part which goes into the completed machine. Of course if there are two or more parts exactly alike, only one drawing is required, and then the draftsman simply puts a note on his drawing thus: "Make Two," or "Make Four," or whatever the desired number may be.

Usually the draftsman who makes the detail drawings is not the one who made the assembly drawings, although in some cases both drawings may be made by the same man. In case a different man makes the details, he must work from the assembly drawings, and hence the latter must be complete and correct if the details are to be correct.

When the drawings go into the shop where the machine is to be built, the pattern-maker, the machinist, and other mechanics will work from the detail drawings, because they show exactly what the various parts are like. An assembly drawing may or may not accompany the detail drawing into the shop. If it does, the mechanic can see where the piece that he is making is to go in the finished machine. But if

there is no assembly drawing he makes the pieces as they are shown in the details, and his responsibility ends there. If the pieces fail to fit properly when the machine is finished, the error is in the drafting room, not in the shop.

After all the parts are made they go to the assembling shop, where the machine is put together. Here the assembly drawing is of importance because it shows how the various parts go together. The machinist who assembles the machine will therefore be supplied with the assembly drawing, and with all the parts at hand, properly made, he turns out the finished machine.

The Designer.

If the machine which we have been considering is something which has never been made before, it is quite proper to ask where the draftsman received his information, which enabled him to make the original designs. He must have had something to work from, because the mechanism to be built must have had an origin somewhere. The answer is that the machine originated with the designer. Having in mind a certain kind of work which he wished the proposed machine to do, he set out to devise a mechanism which would do it. It is of course unlikely that the first idea which occurs to him will prove to be the desired solution, so he tries one after another until the best one is finally discovered and decided upon.

In some engineering offices the designer and the draftsman are one and the same person, but in the larger concerns the tendency is to separate the work, having the designing done by one man, and the drafting by another. If a man is a designer only, the tools with which he works are simply a pencil, an eraser, and a pad of paper. When he sits down to design his machine, and a particular mechanism occurs to

FREE HAND DRAWING

him as a possible solution of his problem, he sketches it out free-hand, so that he may have an opportunity to consider it more carefully. If it looks good, he proceeds to develop the idea, sketching it in as the machine grows in his mind. Certain changes may seem desirable at times, and he simply erases part of what he has drawn and sketches it again according to the new idea. Finally the complete design is decided upon, and sketched on his drawing pad, although of course it is all very rough and unfinished, because done free-hand, that is, without the use of instruments.

Then the designer calls in the draftsman, shows him the sketches and explains the idea to him. The draftsman then makes the finished mechanical drawings from the designers sketches. Of course the draftsman must also be somewhat of a designer himself, because the designer's sketches will probably cover only the main features of the machine, leaving many of the details to be worked out by the draftsman. So it often happens that the draftsman will make free-hand sketches of a number of different parts of the proposed machine, before he decides definitely on the proper shape and size. After the general design and many of the details have been fixed in his mind, he will then take up his draftsmans' instruments and proceed to make the mecanical drawings.

It should be evident from the foregoing that no man can hope to become a successful draftsman or designer if he has no knowledge of free-hand drawing. Such drawing forms the basis for most mechanical drawings, because the free-hand drawing is what the draftsman must work from when making his finished drawing. Every new machine, almost without exception, has its origin in a free-hand drawing,

and hence the latter is the beginning of all engineering drawing.

After free-hand drawing has been mastered, it will be found that mechanical drawing consists in making the same kind of a drawing, but making it more neatly and accurately by means of instruments. Hence a study of free-hand drawing is very essential for anyone who wishes to become a mechanical draftsman. It is, in fact, a long step in the right direction, and will make the understanding of purely mechanical drawing very much easier.

Examination Questions

EXAMINATION QUESTIONS

FREE HAND DRAWING.

Directions.

No scale or ruler must be used in any free-hand drawings. Only a soft pencil and eraser.

LESSON ONE.

Examination Questions.

1. What are the two principal kinds of sketches employed in engineering work?
2. What is the first thing to learn in free-hand drawing?
3. Must the eye or the hand be first trained?
4. Are free-hand sketches drawn to a correct scale?
5. How is the pencil held and the line first drawn?
6. What is the most important element of free-hand drawing?
7. Explain how you would draw a horizontal line? A vertical line?
8. How would you draw an angle? A rectangle?
9. How a square? An equilateral triangle?

Exercises.

1. Draw one hundred straight lines. One hundred vertical lines.
2. Draw a horizontal line one and one-half inches long. A vertical line the same length.
3. Draw five right angles. Five 45 degree angles. Five 15 degree angles. Five 10 degree angles.
4. Draw a triangle. An equilateral triangle.
5. Draw a rectangle three inches long and two inches wide.
6. Draw a square two by two inches.
7. Draw a triangle with a base of one and three-quarter inches.

EXAMINATION QUESTIONS

LESSON TWO.

Examination Questions.

1. Which lines are easier to draw free-hand: straight or curved?
2. Give several ways of drawing a circle without the use of a compass.
3. Name the two principal axes of the ellipse.
4. Give the method for finding the two foci of the ellipse.
5. Which is the easiest way to draw an ellipse free-hand?
6. How is a cylinder represented by a free-hand sketch?
7. What is the method used in shading an object drawn free-hand?
8. How would you draw a square pyramid? A hexagonal pyramid?
9. How would you draw a rectangular prism?

Exercises.

1. Draw a circle by the aid of a silver dollar.
2. Draw a circle by turning the paper around the index finger.
3. Draw a circle 3 inches in diameter free-hand; 4 inches; 5 inches.
4. Draw several concentric circles (inside one another, from the same center).
5. Draw 3 circles of unequal size tangent to one another (touching one another).
6. Draw an ellipse having a major axis of 3 inches and a minor axis of 1½ inches; 4 inches by 1½ inches.
7. Draw a cylinder lying on its side with one of its ends exposed to view at an angle.
8. Draw several (at least three) combinations of cylinders, pyramids and prisms and shade them properly.

LESSON THREE.

Examination Questions.

1. Do objects appear to the eye exactly as they really are in nature?
2. In drawing a group of objects, which one should be taken up first.
3. What determines the distribution of shading on a free-hand sketch of any object?
4. What is the difference between shading and shadows?
5. How does the angle of an object determine the impression of its length to the eye?
6. What is the appearance of a circle placed in a plane parallel to the observer? At an angle to the observer? At right angles?
7. How can an object be represented without sharp outlines?
8. What kind of lines are used in representing an object by shading it?

Exercises.

1. Draw a combination of a hexagonal prism and a cone in three different positions.
2. Draw a cube at an angle and use no sharp outlines, but make up the figure by proper shade lines.
3. Draw a combination of a cylinder, cone and sphere.
4. Draw a cone tilted towards the observer at three different angles.
5. Show three sections of a cone.
6. Show three sections of a square pyramid.

EXAMINATION QUESTIONS

LESSON FOUR.
Examination Questions.
1. What is meant by perspective drawing?
2. How many vanishing points are to be considered in drawing an object in perspective?
3. How are equal distances between similar points affected by the direction of the vanishing lines?
4. How would you draw objects with curved parts in perspective?
5. How are vertical distances represented in perspective drawing?
6. How would you draw an outline of a street in perspective?

Exercises.
1. Draw an outline of a train in perspective.
2. Make a mechanical layout or plan of some manufacturing plant.
3. Show the same plant in perspective, in sharp outline.
4. Shade the sketch made in exercise 3.
5. Copy a sketch in perspective from a catalog.
6. Make the same sketch from memory.

LESSON FIVE.
Examination Questions.
1. What branch of drawing is most frequently used for preparing technical illustrations?
2. What is the difference between an illustration and a working drawing?
3. How can an illustration be prepared accurately without looking at the actual object or a model?
4. What are the principal lines of direction in an isometric drawing?
5. What use is made of shading in technical illustrations?
6. What is meant by guide-lines as distinguished from prominent lines and shade lines?

EXAMINATION QUESTIONS

7. What type of drawing is best to be used for showing the main features and dimensions of a machine?
8. What additional information must be supplied to make a technical sketch of a machine complete?

Exercises.

1. Make a free-hand sketch of your parlor lamp, or some gas or electric fixture.
2. Copy a sketch of some pipe fitting from a catalog.
3. Draw the sketch of the same pipe fitting from memory.
4. Make a free-hand drawing of a small pump by observing it in your own work.
5. Add enough dimensions to your sketch to supply all the information for a prospective buyer.
6. Make a study of three or more catalog illustrations of a technical nature and see if you can copy them from memory.

LESSON SIX.

Examination Questions.

1. Name several occasions when rapid technical sketching is required by an engineer.
2. What material is required for technical sketching?
3. What kind of drawing is used for technical sketching: mechanical, isometric or perspective?
4. What method would you use in making a technical sketch of a machine or structure in place?
5. How is technical sketching used by the designing engineer and draftsman?
6. How would you make a sketch of a structural steel or concrete structure?
7. How would you make a sketch of an electrical switchboard or wiring scheme?
8. What is the difference between "looking" and "seeing"?

EXAMINATION QUESTIONS

Exercises.

1. Make a sketch of some part of pipe in a steam power plant where you are working.
2. Design a piping system for heating a garage and make the necessary free-hand sketches.
3. Copy a mechanical drawing of a building section by the free-hand system.
4. Draw up a detail of a part of a machine from observation or memory, and put in all necessary notes and dimensions.
5. Draw a free-hand sketch showing the wiring of a simple switchboard.
6. Make a sketch showing wiring of an automobile ignition system.

LESSON SEVEN.

Review Questions.

1. What is the importance of free-hand drawing for the practical engineer?
2. What is the importance of rapid sketching for the designer?
3. How are machines originally designed?
4. What is the difference between an assembly and a detail drawing?
5. What instruments are essential for mechanical drawing?
6. What materials are required for free-hand sketching?
7. Why is it not practicable to make all preliminary studies by means of scaled mechanical drawings?
8. What studies are required to enable the student to be trained as a designer?

www.ingramcontent.com/pod-product-compliance
Lightning Source LLC
Chambersburg PA
CBHW020708180526
45163CB00008B/2992